JAMES DEAN IS DEAD!
(LONG LIVE JAMES DEAN)

Jackie Skarvellis

JAMES DEAN IS DEAD!
(LONG LIVE JAMES DEAN)

Revised by James Hogan

OBERON BOOKS
LONDON

WWW.OBERONBOOKS.COM

First published in *Hollywood Legends: 'Live' on Stage* published in 2011 by Oberon Books Ltd

First published in 2018 by Oberon Books Ltd
521 Caledonian Road, London N7 9RH
Tel: +44 (0) 20 7607 3637 / Fax: +44 (0) 20 7607 3629
e-mail: info@oberonbooks.com
www.oberonbooks.com

A catalogue record for this book is available from the British Library.

PB ISBN: 9781786825353
E ISBN: 9781786825360

Cover design by Sergio Maorenzic

eBook conversion by CPI Group (UK) Ltd, Croydon, CR0 4YY.

James Dean is Dead! (Long Live James Dean) was first performed at Above the Stag Theatre with Stephen Cheriton as James Dean on 4 June 2009.

James Dean Is Dead! (Long Live James Dean) by Jackie Skarvellis as revised posthumously by James Hogan was first performed 24-27 May 2018 at The Warren Brighton. It transferred to the King's Head Theatre 26-29 July and then to C-Aqulia 19-27 August.

Kit Edwards	JAMES DEAN
Peter Darney	*Director/Producer*
Julie Addy	*Associate Director*
Emma Tompkins	*Set Designer*
Clancy Flynn	*Lighting Designer*
Sergio Maorenzic	*Photography*

Special thanks to The Jermyn Street Theatre, James Naysmith, Oliver Walker, Jane Dodd.

DEAN: "Spyder Porsche, my baby. A car to die
for, yeah."

On the way to the races we stop off
at Tip's Diner. I get a strawberry
shake... *(Winks.)* and then some. This
cute dude cruises me, with a fuck me
smile. He sneaks out to the John. *(As if
answering a silly question.)* Of course, I
follow! Nice ass, whoa!

"Maybe he <u>don't</u> know who I am.
Hey, I don't think he does. He really
wants me this dude."

Dude or dame, who cares?
Hollywood's all full of sex hungry
people. So all ya need is hunger. I'm
always hungry.

(Introduce engine sound.) So let's go, faster and faster. The road opens up. Yeah, like that dude's hungry ass. Phew! Wish I had the time. *(Beat.)* Spyder's engine purrs like a cat. A cat called Spyder? Stupid thought in my head like a bad tune. A cat called Spyder. Spyder and the cat. The cat and the Spyder. Lord Byron, I need you.

IN'ERSECTION WHOA!"

Silence.

I'm only twenty-four summers old. Rolf is next to me in the Porsche. He survives. The wrench guy, a Porsche mechanic, done a good job on the engine. No problem. The driver of the other car is unscathed. But I don't see

him comin'. One mistake. In a careless moment I split the fame atom. The fall-out showers gold over Hollywood and the fashion industry – white T-shirt, 101's. Greetings cards, posters, coffee mugs. Get it? From now on folks kiss me every day in their coffee break.

Hey, you guys! Kiss me. Kiss me again!

When my Ma died I was nine. Nine fuckin' years old.

I still talk to her. "Where are you now, Ma? Why'd you die and leave me all alone? How do I do it alone? I <u>can't</u> do it on my own!"

I come here all the time when I'm
feeling low. Hold onto the cold stone
to talk to the dead. How tough things
are, stuff like that. Can she hear me?
Does she understand? I do! I talk to
the dead. Any time things get me
down, I visit to this cemetery and cling
to Momma's stone like she's gonna
save me from something terrible.
From what? I don't even know.

My Dad put one word on my
Momma's stone: 'Wife'. What about
'Wife and Mother'?

It's just like they say: You miss them.
Like from now on something is forever
missing in my life. I reach out, but she
ain't there. The light has gone out in
the room. A room I thought I knew.

But now I'm blind. I bump into things
all the time.

My memory ain't working right. I
can't picture her clear any more. So
I close my eyes, think back in time,
but her image escapes me. Can I still
hear her voice? Maybe. Other times
I get lucky. I catch a glimpse of her,
in a shadow on the wall, in a dream.
I kinda see her, kinda. Not really a
ghost, just something flickering in the
corner of my eye, across the room. But
if I turn to look, she's gone. Once she
called my name. Like those times she's
teaching me how to draw and pain't.
How to speak all those poems she
knows by heart and loves. Lord Byron,
see?

Please don't laugh. I am officially
James Byron Dean. Yep. James Byron
Dean. Ma was so big on poetry she
did that, gave me his name. Now I
wish I'd read more of the poems. And
now I've <u>really</u> gotta learn me some
Byron in case I meet the dude. He was
also mad, bad and dangerous to know,
wasn't he? Well, that's what most
people remember about him, not what
he wrote. They know who he fucked,
but they can't recite a single line of
his poems. Mad bad and dangerous
to know. Do folk get hurt on the way?
Don't get in the way.

Shrugs boyishly.

I learned to dance early on. Momma
loved to dance. Graceful like a swan is.
She was certainly something showing

me the dance steps. I had to get it right
though. Tools for living. Right on, Ma.
Living goes on and so I do anything to
get what it takes, to be who I want to
be.

Yeah, I piss people off! They say I'm
all screwed up, crazy mixed-up kid.
Let'em think what they want. Maybe I
want them to think I'm crazy! Maybe I
<u>am</u> crazy. No reason. Okay childhood.
Didn't like Dad a lot, a lot of kids
don't, not after Mom died. But there is
no boyhood reason in my background
for the way I behave now. I was a
<u>good</u> kid. My aunt and uncle and my
cousin in Indiana will tell you. I love
them, and they love me. My Pa sent
me there after Ma died. It was for the
best, and I got the best. Don't nobody
say I was bad all through. Shit, the
things they say.

Hey, Marilyn Monroe says "You are
the only person more fucked up than
me." Thanks Marilyn. So now I am
officially fucked up. The lady has
spoken. If I don't take a shower some
day, or don't brush my teeth am I so
different? Am I fucked up?

That was back then. Now it's different.
Hollywood. You learn Hollywood,
like enlisting. Now I do what it takes
to get what I want. I'm what I am in
the movies. The rebel they want me
to be. Hollywood wild. That comes
with the money – and the people. All
those people who want a piece of you.
THE piece too. Believe me, they all
want that. Who needs a calling card.
Just yank out your dick. Your dick
opens more doors than a passkey. You
act friendly. Act who they say you
are. Yeah, sure, you can suck my dick.

The way I see it, every time someone sucks your dick – dude or dame – it's an audition. The Hollywood audition. And, boy, did I want those auditions.

So it's a game. Will the game ever end? Or will it become ooh sooo "discreeeet". When do the cock suckers and the hungry assholes find their way back in? C'mon! They've got all the dough! What are you telling me? A guy with a billion bucks can't get a fuck any more? Doesn't bother me so much. I'm horny all the time.

Must be Hell for <u>nice</u> boys. Sure as Hell it's Hell. They'd better learn the art of erection. Learn to earn. We know all that stuff. It's the losers who say it's Hell. The ones who don't play

the game. Walk out of the bedroom,
you walk out of Hollywood.

I suppose if I'm true… What the
fuck's true? In Hell you know you're
alive, pain keeps you alive. Stifling
in my skin, suffocating some days.
Like hot pins and needles. You wanna
jump outa that skin, inhabit another's
flesh, but the only way to end it is to
fuck them. Get it over with. It's only
acting. Or just another game. It means
nothing, it's gone! Back to who you
really are.

The car was a mangled wreck. Me
too. I'm was a real mess. Before, I
was messed up on the inside where
it didn't show. Outside I was pretty
enough. But not with a steel spike cut
through my chest. I've left my body

far behind me. Stardust to stardust.
The human body is poor packaging
material. Can't withstand a goddamn
flea-bite.

Hollywood fanfare.

USA rules, OK? It's 1950, we're
gods. It's the Land of Opportunity!
We dropped A-bombs on Japan.
While people are still melting from
the A-bomb and forming grease
pools on the streets of Hiroshima and
Nagasaki, we were busy hatching the
first teenage revolution. America was
one big self-satisfied Mother! Greed,
grab-and-get. McCarthy witch-hunts.
Names were named. A lot of actors fell
foul of that paranoia. It was an era of
paranoia, of suspicion. People like me,
we could have gone to the wall, I was

a rebel, a Rebel Without A Cause. But
American Imperialism rules, OK. And
it still does. The American Dream
gone bad, rotten to the core. We're
God's chosen country. Anybody can
be president, or a movie star! Me, I
chose to be a serious actor. But hey,
what the hell! If Hollywood calls, I'm
free! It's the Land of Opportunity,
ain't it? Sure is! I'm picked for a Pepsi-
Cola ad on TV and I stand out – the
director likes me. This leads onto lotsa
other things, and the director always
likes me. That's when they're not
screaming at me for being difficult,
late, moody, not knowing my lines.
They still just love me. I stand out in
a crowd. I'm not made to be an extra.
They notice me. I'm different. They
dig the difference too, but they don't
know what it is yet. But they will.

Those bastards will love me more – I'll
make them love me.

In New York, I explored everything
about myself. My sexuality, always a
mystery to others, and to me! I had
affairs, not relationships, affairs…
with a lot of men. All sorts of men.
Some rough trade and some not. My
boy dancer wasn't rough. Blue-eyed,
blonde, delicate. I used to pop round
there just for sex.

BOY DANCER: "Well hey there, Jimmy Dean.
(Beat.) I'm always at home for you, big
guy. C'mon in."

DEAN: Amazing sex, no holes barred. We do
it anywhere. The open hallway on the
landing. I'd held onto the door frame
and he took me right there – anyone
coming in might catch us. It added to
the thrill, they'd have got an eyeful! I

pushed myself to the limit! No, I don't have limits. I try everything. And the further I go the better my acting. It gives me a whole new dimension. I mind fuck, I'm good. So, I explore more, get deeper into it. My potential is fathomless…

1952, I'm accepted into the Actors Studio in New York. That's a big break for a boy like me. I can't believe my luck, to walk through those doors where all the greats have gone, and Lee Strasberg: Master of Ceremonies!

LEE STRASBERG: You have a talent, but it is undisciplined. What you do is simple and believable, it has a wonderful quality',

DEAN: So far so good. I wanna revolutionize the stage, I'm gonna create new art forms, a whole new style of acting. I'm gonna set the screen on fire. Sure,

they all wanna fuck me – I FUCK
NOBODY! I get stuck into my scripts,
tell the truth, that's what I like best.
Me and my lines, make the words my
own, fresh, like I'm saying them for the
first time, like a new thought is born.
I really do become the character I'm
playing, I transform into whoever is up
there on the screen. He explodes in my
head and suddenly he's there.

But then it all turned sour like so many

things in my life seem to do. I do a

piece that I prepared for him, it was

a last minute decision to change the

scene and, boy, that one big mistake:

LEE STRASBERG: It's crass! It's crap! Call that
 acting? Call that a performance? You
 oughta been a cowhand!

DEAN: …and on and on. He knocked the guts
 outta me. And an actor's gotta have
 guts, or what's left? I don't know
 what's inside but it's gotta come out

when I act. I'm the first postmodern
actor. It's the truth. It's the goddamn
truth! I create a style that's all my
own – in the moment, that's what
it's all about. Being in the moment!
It's like making love: you can't do it
if you're somewhere else! Clift does
gets it – in the moment, Brando too,
pretty much all the time. That's what
I'm trying to do! To be TRUTHFUL
EVERY MOMENT! But Lee doesn't
get it. He's abusive, and I can't take it!
Time to do the rounds, rejection after
rejection, soul destroying. I didn't just
knock, though, I hammered like hell!

Hi! Jimmy Dean! Yes sir, I brought
a new piece from a screenplay by a
friend of mine – oh, you don't wanna
know what it's called? Yeah, I play
this guy who's all screwed up, right...
ok. I got this thing, this illness, it's
inherited, ya see. My Daddy was a
no good bastard so he gave me this

disease, it's congenital, it's in my
blood, it's not my fault, I inherited it
and, and... No, it's not right, I'd like
to start again, I think I got some words
wrong – I'M TRYING TO GIVE
A TRUTHFUL PERFORMANCE
HERE, GODDAMMIT! Sorry! I
just wanna try again, I'm just getting
into it now, give me a minute! I need
more time. No, I am not wasting the
studio's valuable time! Do you want
a real performance by a real actor or
just some manufactured shit? No! I'm
sorry! What? Aw, shit, have it your
own way! You don't want me to do the
speech again? Well, FUCK YOU!

That's how it was: that's how I was!
I took no prisoners, no shit! Self-
obsessed me? Yeah, to the bitter end.
A bastard, bastards make the best
actors!

At this time, I got to cut my teeth on other art forms; I studied art; I even studied dance; and of course I played the bongos.

Also about this time I start living with Rogers Brackett, older man with cash, and style. Cash opens doors, style helps too. 1952, New York. Hanging out at the Algonquin, just sitting around, sipping bourbon in the lounge – I hated that! He wanted me to do it though, to show me off to his friends, like a new lapdog! Bitchy queens! All they talk about is who is doing what to who! Boring! One night I counted fifteen names dropped! Fifteen! Fifty times! All the time, me muttering sons of bitches, all of them. Rogers didn't like that at all!

So he was keeping me, so what!

"YOU DON'T OWN ME!
NOBODY OWNS ME!"

But he did introduce me to lots of his
friends, influential man on the scene. I
couldn't handle this for much longer.
Move out, move on…

Guess I'm too tricky to live with. What
was good about it all?

Pause for thought.

Yeah, the book. *The Little Prince.*
Rogers gave me a copy. Y'know, how
people do that when they wanna teach
you something, give you a book and
stare straight at you. A book, when
what you really want is a 100 dollar

bill. Anyhow, this time the book blows my mind. *The Little Prince* by Antoine de Sain't-Exupery. This book is now my Bible. I read it over and over.

A little guy from another planet falls to Earth and lands in the Sahara desert. There he meets a pilot whose plane has crashed. But before that he meets a fox who tells him a secret. The secret, here it comes:

The most beautiful things in the world are invisible to us humans. They can only be felt by the heart.

I feel it! And that's how I Iived, how the child in me lived, feeling the truth, just like the little Prince, a child who fell to Earth. Ah, but did I light up the firmament? I'm not so sure.

People wonder about me, who I really
am, sexually. I had girlfriends, and
boyfriends. Lots of 'em. I'm no freak,
though. There are millions like me.
Twilight people! Guys and gals.

One guy, Jonathan Gilmore!

GILMORE: What the fuck, Jimmy!

DEAN: Just hold it there please.

I really liked Jonathan. He was an
actor. Beautiful guy! Good looking?
Jeeez! I wanted to, y'know, go all the
way. But we fooled around a bit. Once
I grabbed his cock through his pants.
It was in a restaurant. Under the table!
Couldn't stop myself. Didn't go down
well. But we talked about a lot of
things: acting, the hottest guys, fucking
guys... It was all talk, no action with

him. So it never worked out. He was
too tight, uptight, tight-assed! I tried,
but he couldn't take it, poor guy. I
guess it just wasn't his time.

There's people bought and sold in
this city like it's a butcher's shop,
an abattoir! Buyers and sellers eye
each other up – like the meat market
hanging on a hook. That one's tasty,
that one's too fat, that one's lean
and sinewy. It's the meat rack. Street
traders check your worth, what do
you measure? That's Hollywood, New
York: anywhere there's always the
meat rack. How tasty is your joint?

I'm good enough, they laugh at my
accent. I'm just a hick – a small-
town boy! Guess I am. Fuck 'em
though! I'll show them who I am,

the motherfuckers! I can do any role
– anything! Just gimme the chance,
will one of those bastard gimme a
break! Of course they won't, unless
I play their kinda right game. Fall to
Earth like The Little Prince? Oh no.
Fall in with the homosexual mafia
in Hollywood. The bi-i-g boys. The
powerful guys, talking big. Like
everything's gotta be big big big... You
audition, audition for what? They're
sizing you up if your're pretty enough.
I mean SIZE you up, while they suck
on their big fat cigars. You're on the
menu, Baby. You stand there nervous,
or trying not to be. Them in their bi-
i-g executive armchairs: 'Hey, Boy!'
They call you boy like you're some
shoe shine boy, 'Hey, Boy! Before
I can cast you kid, I like to get to
know my actors better! Know what I
mean?' I sure as shit know what that

means. So you smile and nod. Next
thing you're in his bedroom. He kicks
the door closed behind, takes off his
jacket. I take off mine. We face each
other like two cowboys in a standoff.
He makes the first move. He grabs my
belt. Hard. 'Get my drift boy?' 'Sure,'
I say and smile the smile of consent,
maybe more of a grin, no grimace.
Don't be <u>too</u> nice. Yeah, I get his drift,
right in my face. I suck dick and had
my dick sucked by some of the most
powerful men in Hollywood. No
names but do take my word for it.

It's a tradition. It opens lotsa doors.
When you're broke and down on your
luck – desperate for a job, you do
anything. They know that. Yeah, I did
anything. You make your choice, take
that chance. Life too tough not to.

Strictly off the record, I've had my
cock sucked by five of the biggest
names in Hollywood. They say
Hollywood's no place for a fag, which
is funny cos it's full of them and I
wanted, more than anything on this
Earth, to get some little part, to do
something. Sometimes they invite
me to dinner overlooking the ocean
and give me drinks and ask how long
could I go on holding out? That's
what I want to know! And the answer
was that it could go on until there was
nothing left of me, until they had all
what they want of until nothing is left
– just one big fat zero!

Baby, I was up for whatever it takes.
I was a big hit with the fist-fuck set.
Up for anything – even if it hurts.
Boots, belts, bondage. And cigarettes.
Cigarette burns all over me. Yeah,

they used my body to stub out
cigarettes. Look! That's how I earned
my nickname: The 'Human Ashtray',
like this: *(Takes cigarette and burns.)*
In time I got used to it. Hell! I even
started to enjoy it! Like I say, at least
with pain you know you're alive!

The job I finally landed was in *The
Immoralist*, a play by André Gide.
Great role for me! I played an Arab
houseboy, a homosexual called
Bachir, who seduced his master. Great
part. Though I had issues with the
director and the actor Louis Jourdan.
They thought they knew it all! But I
showed them, just when I was about
to talk I cracked it in a big way with
the famous scissor dance! It made
my name, I hit all the headlines! The
critics loved me – I was their darling,
just for once! That famous, infamous

scissor dance! You wanna see it?
Watch: Lemme show you what all the
fuss was about!

Scissor dance.

Yeah, they certainly all loved it! But
then, at the very height of my fame,
I quit! I handed in my two weeks'
notice. They were stunned: they didn't
know why. But I did! It was because at
that time Elia Kazan called my agent
and offered me the role of Cal in *East
of Eden.* Now, I wasn't gonna turn
down a lead role in Hollywood just to
be on Broadway, now was I? Hold the
bus!

Hollywood fanfare

Tinseltown HERE I AM!

Yeah, but it's not so great personal-
wise. Casual encounters. An empty
kinds life. A full working day, but
spent my nights alone. No magic
fox appeared to tell me a secret. So,
enter Jack Simmons, my sometime
lover. He was very devoted, jeez! He
even tried to change his looks to be
like me: a nose job! Dressed like me,
like we're twins! Making love to my
mirror image, just like jacking off! Talk
about obsessed. Told all his friends:
'I'm gonna be with Jimmy Dean long
term!' And he did, for a long time,
copying me. Ain't that weird? He even
kept a pair of my boots in a glass case,
like a shrine! He made a holy relic out
of my body! One time, he hit on my
old-time love Jonathan Gilmour out
of jealousy. But I didn't care! I was a
star by then, by that time James Dean
had arrived. The whole world knew

my name. I was interviewed by all the press.

Mr. Harold Thompson, *New York Times*, pleased to meet you sir. No sir, I never did read the novel of *East of Eden*, I prefer the adaptation. Yeah, I felt I understood the part, if I had a problem, Kazan would set me straight. Strasberg? Incredible man, a walking encyclopaedia. New York? Love it! I feel in cadence here. New York is so vital and so fertile. Out there in Hollywood, behind all that glass, there are people who are just as tuned in. The only problem for this cat, me, is not to get too lost in there! No, no, I didn't go to the premiere of *East of Eden* – too much pressure...

So now, women I knew... Pier
Angeli. What was it about Pier Angeli
and me? Were we a match made in
Hollywood heaven? Even I believed
it for a time, believe the Hollywood
fanzine talk. How romantic for a guy
like me, a guy who likes men, to marry
a pretty little thing like Pier. Who
knows how things might have worked
out. It sure woulda been different!
Maybe I wouldn't have died and
become a legend. Had kids maybe.
Son of James Dean! And me fat and
fifty, and a mess! Hell No!

Song: Going to the Chapel.

Miss Parson, pleased to meet you!
Please sit down! Best behaviour with
this one, Louella can make and break
reputations! Yes ma'am, truth is: I'm

beat. Three pictures, back to back
almost. I need a rest! Yeah, they say
I've done the Hollywood thing, but
the truth is, I'm exactly the same as
I was when I didn't have a dime. I
need a break! Yes Ma'am, pleasure to
meet you too. Phew! That's one mean
mother! Romance? Pier and me?
Yeah, we're very good friends. Marry?
Who knows, we'll see what happens.
Engaged? I'm saying nothing, who
knows, we're still very young. No,
no more questions. Shit, get me outa
here!

I guess if it could be any woman, it
would be her: Pier, my angel. She
might have saved me from death,
but not from fame. And then where
would my legend be? On some faded
cutting-room floor where dreams
die. Anyhow, I like my *(Hesitates.)*

ambiguity. Isn't that part of me too?
No, best leave things the way they are.
Keep away from Pier, don't destroy
her.

Pier married Vic Damone. Good,
Catholic creep! Greaseball! Well, good
luck to 'em! *(Motorbike.)* There's a
story I roared away from the church
crying on my motorbike. Sure, I drove
away knowing I'd lost her. Sure, I was
depressed. So, I lost myself among hot
guys. All kindsa guys! But you don't
really forget someone fucking around.
That don't work, memories make sure
of that the heart hurts all night long,
when you're cold and alone – even
with a stranger beside you. You wish it
was the person you long fort, not these
guys who screw you, use you, throw
you out at dawn. The dawn always
comes up cold and you're alone beside

a stranger you met the night before on
Boulevard of Broken Dreams, just like
the song…

Song: Boulevard of Broken Dreams.

The city's strange, big scary neon.
I'm still a small-town boy from a hick
town. Country boy, farm-hand, that's
me! I don't fit in anywhere. I call
Brando, tell him everything, he's my
god! I'm hours on the phone, talking
to him, he's the nearest thing to a
father confessor. He always picks up
the phone and listens, but I think he's
just laughing. He never speaks, never
answers my questions, but I know he's
hanging on the phone, listening and
it makes me feel less alone. I can hear
him breathing, I feel him thinking.
Why won't he speak? Bastard! Talk

to me! Like God, he remains silent.
Cities, artifice…

Let's get busy. I take lessons in
dancing with Eartha Kitt; I take classes
– anything. And the city never sleeps
and neither do I. I haunt the bars, I
hunt in the bars. You meet the other
insomniacs like yourself, hollow-eyed,
sleepwalkers in the twilight world.
Sometimes I fuck 'em, sometimes I
send 'em home.

More close encounters that mean
nothing. All in the dead of night while
the neon shines on us relentless. You
can watch people fucking. Sometimes
I do.

I tell myself it's all part of my training,
to observe a darker side of human

nature at night. I tell myself I to break
new ground with my acting technique.
I tell myself it's all good experience.
(Laughs.) So all sortsa people get
caught in my *(Hesitates.)* research.
Most of 'em disappear with the dawn.

First time I finished a film, I was
exhausted – but elated too. I could
feel it – A STAR IS BORN! I went
to the premiere of that film, cameras
popping. But I didn't go to *East of
Eden premier*, too much like my own
life: a son tries to win his father's love.
Kazan got it right. The minute he
met my Dad he knew exactly what
was going on. He sensed it. Steinbeck
too! He got it right. 'He is Cal', he
said when he met me. They sent me
off to the desert to get a tan, I looked
pale. So, I went to the desert, got a tan
and put on a few pounds. With my

first thousand bucks I bought a red
MG, she was fast, she was fabulous, a
real firecracker. They cast Raymond
Massey as my Dad, he sure as hell
was hard to work with. We clashed.
He thought I was a heel, a dog! But
I couldn't be any different. We just
never hit it off. He was old school,
never changed the lines, threw him if *I*
did – and I changed the lines a lot. He
HIT THE ROOF! I got myself a bad
name for being difficult. It stuck like
shit to a blanket.

Like the character I played in *Giant*.
He doesn't dig Rock Hudson, no siree,
he doesn't. So I'm mean to him, real
mean, and it kinda gets Rock down.
But that's the way things are between
them. I really got to him. I burned him
down, I burned down Rock Hudson!
Jesus I was mean, but it worked! Look

at how we bounce off each other on
screen – like lightning! He hated me
for real, but it got results! IT WORKS!

People are dumb. They need someone
to worship, imitate. Movies mean so
much to them. The stars shine down
from the screen to light up their lives.
It's magic. Or maybe even prayer.
The movie gods throw stardust over
them. Fan magazines bursting with
stories, what I eat, what I wear – 101's
have never had it so good. Fan clubs
spring up overnight. My picture's in
every newspaper. My name that's
on everybody's lips. Those lips will
devour me if I let them. Eat me whole,
eat me alive, eat a piece of my flesh
like a sacrament, the body of their
God! Phew! Crazy stuff!

I put all that shit aside and think about real things. I met this English actor once, Alec Guinness. An English gentleman. Serious actor, does all the Shakespeare. I was standing by my car in LA, my Spyder Porsche when he said the strangest thing: 'Do not get into the car', he said, 'I have a bad feeling about it.' Now ain't <u>that</u> weird! Maybe all great actors are part psychic. Is that's how we do it?

Pause.

There's another thing I wanna say. I had my picture taken lying inside a coffin. Don't know why, a sudden urge to lie down in this coffin, have my picture taken. It was at Hunt's Funeral Parlour, where they fixed Momma for burial, made her look real pretty. I

was on this photo shoot hoping to get
my face on the front of *Time* magazine
when we came to Hunt's. I just got in
and told them to 'shoot'! *Time* turned
it down.

Maybe I <u>am</u> in love with death after
all. Death on my mind. So lying in
that coffin I sensed what dying is.
No, I never had a real death-wish,
not consciously. always want to
experience everything: strangulation,
suffocation. They say you get a last
powerful orgasm when you're hanged
by the neck. Yes, I guess death
fascinates me.

(Sense of wonder.) Hey, look, the stars.
Anyone around? Who's out there?
(Doubt.) Uh-oh.

When my time passes into no time,
nowhere, no one will remember a
single line I say in the movies. Can
they even now? That's what the great
Lord Byron and forgettable me have
in common. Forgettable. Our work
is as disposable as our fragile bones.
Gone and WILL be forgotten. Takes
a while longer to reach total oblivion,
but we're heading that way.

Actors are only as good as their next
job. At least, that's how they feel. TV
prolongs our movie lives 'cept we ain't
getting paid any more. No more acting
roles, no more me today, only my
movies of yesterday.

Next, my 101 jeans. Sot who wears
them now and thinks of me? All the
kids wear them. From here I see kids

standing in line at the movies. *Rebel
without a Cause.* For fuck's sake Lee
101 Riders are making millions. Am
I the big swinging dick of 101's? Er...
apparently so, by reputation. They go
to bed at night and fantasize about me,
then fall asleep before I get in there.
That's forgettable.

My other two movies have not yet
been released. I wear denim in all of
'em.

The Little Prince who fell to the Earth.
(Disillusioned.) I wonder.

Was that me? Is my story. Me, the
Little Prince that fell to the Earth?
(Sniggers.) Hey, listen. I'm still falling.
The secret, only the human heart feels
the truth? That's the secret: live fast,

die young. That's my secret. *The Little Prince?* 150 million copies sold and the world ain't gotten any better.

And I am him. I wanted to film his story, to be him on the screen but maybe I already am him. I wanted to make his life into a film, this book that I have loved and lived with for so long, but unless someone else comes along, that's a book that will never be filmed, because it's mine and now I'm so long gone they've forgotten – oh, not about me! There are still plenty of fans in pursuit of their own death ride, but they've forgotten HIM. The Little Prince. It's like Sleeping Beauty, waiting for the Prince's kiss. She waited a long time, a hundred years. I'll kiss that little prince someday and wake him up again, meantime I have to live with what happened – hear

that sound? *(Crash.)* Again and again!
Somebody must wake him into new
life again, from beyond the grave.
Somebody, anybody, please help!
Somebody come and kiss the Little
Prince, he's still there somewhere.
Somewhere like an embryo, waiting
for that kiss, just waiting to be born.

I wanted to be like him, in life and
in the movies. But I wasn't. So watch
out. The child in you goes different
ways. Route 666 in my Spyder Porche.
That's where I'm heading right now.

See ya..

Car Crash.

The End.

WWW.OBERONBOOKS.COM